Legacy
GIFTS FROM A GRANDMOTHER

Compiled by Elizabeth Koppinger

Papier-Mache Press
Watsonville, CA

Copyright © 1995 by Elizabeth A. Mikesell. Printed in the United States of America. All rights reserved including the right to reproduce this book or portions thereof in any form. For information contact Papier-Mache Press, 135 Aviation Way, #14, Watsonville, CA 95076.

00 99 98 97 96 95 5 4 3 2

ISBN: 0-918949-68-8 Softcover

Cover art by Elizabeth Koppinger
Cover and interior design by Elizabeth Koppinger
Composition by Leslie Austin
Photograph by Rick Luettke

Library of Congress Cataloging-in-Publication Data
Mikesell, Elizabeth A., 1965-
 Legacy: gifts from a grandmother / Elizabeth A. Mikesell.
 p. cm.
 ISBN 0-918949-68-8 (softcover : alk. paper)
 1. Grandmothers-Miscellanea. I. Title.
HQ759.9.V36 1995
306.874'5-dc20 95-18683
 CIP

To:

From:

INTRODUCTION

My grandmother began life as a daughter and a sister. She was then a wife, a mother, and finally a grandmother. She watched me receive my first bath when I was one day old. As the days and years passed, she guided my mother through the trials of child-rearing, serving as the overseer of two younger lives such as she had already lived.

Gramma is part of my earliest memory. Even today, as I approach thirty and stand a full seven inches taller than her, I always picture her face above mine. I see her exactly the same way I did when, on my tiptoes, I measured only as tall as her apron tie.

I spent countless hours with Gramma in her kitchen, making crayon drawings at her breakfast table. Bundled in soft nightgowns and knitted afghans, I watched fireflies from her side porch. As childhood gave way to adolescence, I spent weekends playing cards

on that porch in the summertime, sipping iced teas and listening to her stories about my mother and her sisters when they were little girls. I slept in the big, white four-poster that had been my mom's bed until she married. At twenty-eight, I still enjoyed "tuck-me-ins" with a kiss on the forehead when I spent the night with Gramma. She watched me from the front pew of our church when I married, and comforted me through the loss of my first child, born prematurely.

Recently, my family and I became accustomed to caring for my grandmother in much the same way she had cared for us most of her life. Then on August 31, 1993, my grandmother suffered a massive stroke. When I kept vigil by her bedside, I found myself remembering the many things my grandmother had taught me over the years. I began to jot them down and stick them to my refrigerator at home.

Soon my purse, glove compartment, and kitchen were overflowing with small reminders of her lessons. And those lists became this book. Some of the "gramma-isms"

you'll read here are practical guides for everyday life, others represent a wisdom garnered over a lifetime. I've found that all of them have their place.

Today Gramma is slowly recovering from her stroke. And while her cognition regarding space and time are not yet completely intact, she is still very much the same wonderful woman I have known all my life. The time I spend with her now, and the countless lessons learned from her over the years, were Gramma's legacy to me. It began the day I was born and will continue long after I have whispered her words into the ears of *my* grandchildren.

I hope you'll enjoy reading this book as much as I enjoyed writing it, and pass it along to someone you care about when you're done. Gramma approves of sharing.

Elizabeth Koppinger

January 1994

For my gramma, Therese C. VanWormer

"A lifetime of knowledge and practical experience
from someone who has seen it all."

1. Eating Play-Doh will give you a stomachache.

2. Always test three cookies first before baking the whole batch.

3. If something from the refrigerator smells funny, throw it away, even if the expiration date is still good.

4. "If you don't get out of that bed you'll rot in it."
(*or, "Getting up late makes you tired all day."*)

5. If you unwrap a gift carefully, you can use the wrapping paper again.

6. Go to church on Sunday.

7. Always listen to what little children have to say.

8. Love people with food (especially Polish coffee cake).

9. Slow down at yellow lights, don't speed up.

10. Get a dog—
one who'll sleep at the end of your bed
and bark at the doorbell.

11. Get to know your neighbors.

12. Pick black-eyed Susans and Queen Anne's lace in the summer, and bring them to your mother.

13. Catch fireflies in a jar, but always let them go.

14. Never go to bed angry.

15. When you give your baby a bath, wrap him or her in a towel right out of the dryer.

16. Learn to say a few things in the language of your ancestors.

17. Keep photo albums.

18. Learn who the people in your old family pictures are, and listen to the stories about their lives.

19. Grow African violets on a windowsill in your kitchen.

20. Marry for love.

21. Wear glasses if you need them.

22. Be proud of your family, and tell them so.

23. Read the paper and watch the news on TV.

24. Try new recipes.

25. Make new friends wherever you go.

26. Shop the sales at good department stores.

27. Clip coupons.

28. Cherish your brothers and sisters.

29. Your health, not your job, comes first.

30. Get enough sleep.

31. Spend the night with your grandparents sometime, no matter how old you are.

32. Wear an apron when you cook.

33. Clean your house early on Saturday mornings.

34. Kiss your parents when you come in the house.

35. Tell your spouse every day that you love them.

36. Visit relatives who have moved out of town.

37. Go to family reunions.

38. Add dumplings to beef stew.

39. Carry pictures of your family in your wallet.

40. Clean up as you cook,
there'll be less of a mess after you're done.

41. Wear your boots.

42. When you're on vacation, send postcards home.

43. Keep your hair out of your face.

44. Get a checkup once a year.

45. Change the sheets once a week.

46. Hang wash out to dry in the summer.

47. Be a good listener.

48. Take good care of your teeth.

49. Take in stray animals,
even if it's only to find them a good home.

50. No holiday dinner is complete without a Jell-O mold.

51. Don't make fun of the Jell-O mold.

52. Don't get up and leave the dinner table right after you're finished eating. Stay and talk.

53. Keep your young grandchildren's artwork. Show it to them when they've grown up.

54. Finger paint.

55. Wear clean underwear.
("God forbid you get into an accident; what would the doctor think?")

56. Always make time for family dinner. Serve it at the kitchen table, not in front of the TV.

57. Don't get too much sun.

58. Send holiday cards.

59. Celebrate Grandparent's Day.

60. Write long letters to out-of-town family; call them when the rates are lowest.

61. Read the Bible.

62. Read *Reader's Digest*.

63. Grow your own tomatoes.

64. Respect the president, even if you didn't vote for him.

65. Bake a potato instead of microwaving it; it does taste better.

66. Learn to make homemade chicken soup.

67. Ask your grandparents what things were like when they were little.

68. Know who your children are dating.

69. Raise your children to be strong and compassionate.

70. Watch *Gone with the Wind*.

71. Read a romance novel occasionally, no matter how old you are.

72. Encourage creativity.

73. Love your children unconditionally.

74. Invite your grandchildren over on prom night to meet their dates and show you how great they look.

75. On Mother's Day, give gifts to pregnant women, too.

76. Help your mother clean the house.

77. Hold hands.

78. Take your grandmother shopping, and let her buy you lunch.

79. Bring lunch over for your grandmother.

80. Hug.

81. Light candles.

82. Visit your grandmother on a regular basis.

83. Surprise someone with a card or flowers.

84. Invite your grandchildren to help you put up the Christmas tree. Tell them the history behind some of your older ornaments.

85. Pass along family keepsakes; tell who they belonged to and why they're so special.

86. Soothe a cold or stomachache with hot tea and toast.

87. Spring clean.

88. Pray.

89. Plan for your retirement.

90. Try not to use credit cards.

91. Plant flowers in the spring.

92. Grow a rose garden.

93. Learn how to hang a spoon from your nose.

94. Eat at the children's table every once in a while.

95. Watch your neighbors' house for them when they're gone. Take in their mail and water their plants.

96. Give out candy at Halloween.

97. Listen when older people are talking, even if you've heard the story before.

98. Keep a full cookie jar.

99. When at work, always take a call from a family member.

100. Attend your children's and grandchildren's extracurricular activities.

101. Go out of your way to help people.

102. Hold a garage sale.

103. Make your spouse your best friend.

104. Say you're sorry.

105. Never underestimate yourself.

106. Go to high school plays and musicals.

107. Kiss your child and tell them everything will be OK.

108. Kiss your parent and tell them everything will be OK.

109. Take your dog with you for a ride in the car, when you can.

110. Don't slouch.

111. Wear bright jewelry.

112. Write thank-you notes for wedding gifts promptly.

113. Make time for yourself.

114. Take a hot bath with fragrant bath salts.

115. Indulge yourself now and then.

116. Have a handknitted afghan.

117. Drink hot milk when you can't sleep.

118. Smile.

119. Laugh.

120. Tickle.

121. Cuddle.

122. Don't quit.

123. Play the lottery.

124. Believe in miracles.

125. Learn from your mistakes, but don't beat yourself up over them.

126. Expect the best.

127. When someone is grieving, sometimes just being there is enough.

128. Forgive.

129. Roll pennies and take them to the bank.

130. Allow people time to grieve.

131. Learn to do simple book work and to balance a checkbook.

132. When a child tells you they have to go to the bathroom, take them right away.

133. Invest in good clothes, but buy them on sale.

134. Don't wear heels that are too high to walk in comfortably.

135. Expect respect.

136. Remember that money won't buy happiness.

137. Let your grandchildren's friends call you Gramma, too.

138. Always toast the cook at holiday meals.

139. Take a prepared meal over to friends who are going through a difficult time of loss.

140. Ask someone how they are because you really want to know, not just as a greeting.

141. Make a double batch of spaghetti and freeze half of it for later.

142. Eat lots of vegetables.

143. Bake homemade coffee cake.

144. Establish your own traditions.

145. Always celebrate family birthdays with cake and ice cream.

146. Use good manners.

147. Invest in good china and use it.

148. Rinse dishes before you put them in the dishwasher.

149. Make tin roof sundaes with hot fudge at home.

150. If you see something that needs to be done, just do it. Don't wait to be asked.

151. Respect your parents.

152. Cry when you need to.

153. Model the behavior you want to see in your children.

154. Laugh at children's jokes.

155. Refuse to be defeated.

156. Keep your own counsel.

157. Plant daffodils and crocuses in the fall—as spring approaches you'll be glad you did.

158. Wear your wedding ring.

159. Buy church cookbooks.

160. Have a hot water bottle.

161. When you have a cold, rub Vicks on your chest *and* under your nose.

162. Pay bills promptly.

163. Visit the gravesides of loved ones who've passed on and leave flowers. It's more for you than it is for them.

164. There is a heaven.

165. Save room for dessert.

166. Call your grandmother when you get home.

167. Don't overdo.

168. It's easier to go up than to go down.

169. Wear red, white, and blue on the Fourth of July.

170. Braid your little girl's hair.

171. Make fried bologna sandwiches.

172. Clean with Murphy's Oil Soap.

173. Take care of your hands.

174. Use fabric softener.

175. Keep a kettle on your stove.

176. Be interested in other people's lives.

177. Don't talk back to your mother or father.

178. Hold birthday parties for young children, and let them invite all their friends.

179. Always bring something when you're invited over for dinner.

180. Don't compare your grandchildren or children to each other; they all have special gifts.

181. Share your toys.

182. Share your clothes.

183. Share your food.

184. Share.

185. Send Christmas cookies to out-of-town family.

186. Always remember Valentine's Day.

187. When you're in church, sing the hymns, even if your voice isn't so hot.

188. Start your Christmas shopping early.

189. Take part in conversation.

190. A little spit on a hankie to clean your face never hurt anyone.

191. Learn to polka.

192. Go to ethnic festivals.

193. Volunteer at your church.

194. Keep candy dishes filled with Brach's pink peppermint candies.

195. Don't eat right before dinner.

196. Put tissue on the toilet seats in public rest rooms.

197. Buy plane tickets for trips well in advance.

198. Invite your neighbors over for coffee.

199. Call your grandchildren "honey."

200. Keep your windows open in the summertime.

201. Take a family vacation at a cottage on a lake.

 202. Be sentimental.

 203. Be sympathetic.

 204. Be strong.

205. When a child tells you a secret, keep it.

206. Help little children make Mother's Day gifts.

207. Don't bite your nails.

208. Love your children's and grandchildren's spouses; they're family too.

209. Take a nap if you need it.

210. Stay up till midnight on New Year's Eve.

211. Hard work never hurt anyone.

212. Don't drink too much.

213. Buy good pots and pans.

214. Have a glass punch bowl.

215. Dust.

216. Keep your closet clean and organized.

217. Have an "everything drawer" in your kitchen.

218. Don't date boys in fast, flashy cars.

219. Honor your marriage vows.

220. Tell your grandchildren about their parents' courtship.

221. Always try your best.

222. Take pride in your appearance.

223. Keep your chin up.

224. Nurture a creative outlet.

225. Save rubber bands and reuse them.

226. Save Cool Whip containers and reuse them.

227. Bake apple pies in the fall, cherry pies in the summer.

228. Use good grammar.

229. Work in your own garden.

230. Make iced teas with lemon and no sugar in the summer.

231. Make your bed in the morning.

232. Learn to type.

233. Keep a recipe box.

234. Don't let the laundry pile up.

235. Praise your spouse's home improvement efforts, whether they work out or not.

236. Buy a house with a basement.

237. Invite family and friends over to dinner.

238. Don't rush.

239. Adopt a child.

240. Nothing tastes better in the summer than corn on the cob with lots of butter and salt.

241. Pick your own strawberries.

242. Eat bananas.

243. Kiss your grandmother.

244. Call home.

245. Learn to cook.

246. Eat dinner out occasionally.

247. Go to matinees.

248. Read to your children and grandchildren.

249. Brush your child's or grandchild's hair.

250. Run through the sprinkler.

251. Write dates on the backs of school pictures.

252. Take home movies.

253. Have a lace tablecloth.

254. When you can't sleep, count your blessings.

255. Keep a box of baking soda in your refrigerator.

256. Don't throw your clothes on the floor.

257. Remember what it felt like to be sixteen and in love.

258. Accept people for who they are.

259. Don't compromise yourself.

260. Learn to laugh at yourself.

261. Remember, things could always be worse.

262. Wash your kitchen floor on your hands and knees; a mop doesn't work as well.

263. Notice the color of people's eyes.

264. Receive a compliment graciously.

265. Don't argue in public.

266. It is better to have one good friend than a hundred acquaintances.

267. Visit the home your grandparent grew up in and take your grandparent with you.
If you can't go in, drive through the neighborhood slowly.

268. Walk to church if you can.

269. Learn to play canasta.

270. It's better to be overdressed than underdressed.

271. Let someone who needs it cry on your shoulder.

272. Make cutout Christmas cookies, and decorate them with colored sugars.

273. Hold on to tradition.

274. Lock your car doors at night.

275. Always wear your seat belt.

276. Keep a phone by your bed.

277. Love is what you do, not what you say.

278. Make snow angels, whether you're five or one hundred and five.

279. Don't watch too much TV.

280. Press roses into books.

281. Let yourself sleep in occasionally.

282. Weed.

283. Speak your mind.

284. Take tissues to weddings-even if you don't cry; the person next to you might.

285. Eat well.

286. Drink at least one glass of milk a day.

287. Bake from scratch when you can.

288. Keep fragrant sachets in your linen closet.

289. Make the most of what you have.

290. Forgive and go on.

291. Make room for quiet time.

292. Celebrate Fat Tuesday and give something up for Lent.

293. Sometimes it takes more courage to stay than to leave.

294. Be a patient listener.

295. Send flowers to someone you love for no reason.

296. Learn to play the piano.

297. Hold hands with your grandmother.

298. You can accomplish more by whispering than by yelling.

299. Play fair.

300. Trust your instincts.

301. Open a savings account.

302. Keep a penny jar.

303. Always have a spare tire.

304. Say your prayers every night.

305. Be the engine, not the caboose.

306. Can fruits and vegetables in the summer.

307. Never underestimate the power of your own determination.

308. Always tell the truth, no matter how hard it is.

309. Never stop learning.

310. Jump in a few puddles after spring rains.

311. Learn from every new experience.

312. No one can be a hero on an empty stomach.

313. Life's best moments are the ones we least expect.

314. Look people in the eye when you speak with them.

315. Tell your grandparent that you love them.

316. Know that your grandma loves you.

"Life is a journey,

measured not by one heroic action,

but by the living of each day

to its fullest."

(*"So make sure you eat a good breakfast."*)

—Your Favorite Gramma-isms—

—Your Favorite Gramma-isms—

—Your Favorite Gramma-isms—

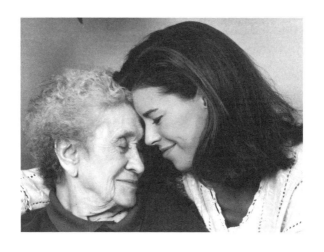

Elizabeth Koppinger is the oldest granddaughter
of Therese C. VanWormer.
Elizabeth is a graphic designer who lives and works in Sylvania, Ohio.

Quality Books from Papier-Mache Press

At Papier-Mache Press, it is our goal to identify and successfully present important social issues through enduring works of beauty, grace, and strength. Through our work we hope to encourage empathy and respect among diverse communities, creating a bridge of understanding between the mainstream audience and those who might not otherwise be heard.

We appreciate you, our customer, and strive to earn your continued support. We also value the role of the bookseller in achieving our goals. We are especially grateful to the many independent booksellers whose presence ensures a continuing diversity of opinion, information, and literature in our communities. We encourage you to support these bookstores with your patronage.

We publish many fine books about women's experiences. We also produce lovely posters and T-shirts that complement our anthologies. Please ask your local bookstore which Papier-Mache items they carry. To receive our complete catalog, send your request to Papier-Mache Press, 135 Aviation Way, #14, Watsonville, CA 95076, or call our toll-free number, 800-927-5913.